Cycle
of
Violence

One hundred copies have been
slipcased, numbered and
signed by the artist.

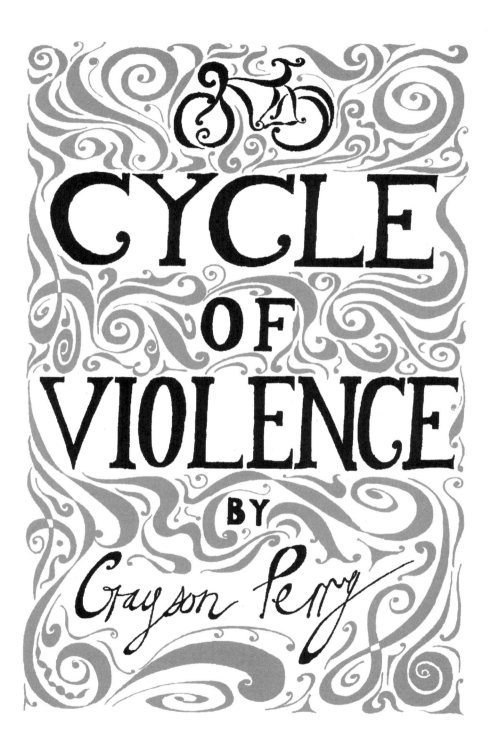

CYCLE
OF
VIOLENCE
BY
Grayson Perry

Published by Atlas Press,
27 Old Gloucester St., London WC1N 3XX.
©2012, Grayson Perry
This edition ©2012, Atlas Press
All rights reserved.
Printed and bound in the UK.
A CIP record for this book is available from
The British Library.
ISBN: 1 900565 61 7
ISBN-13: 978-1-900565-61-5
USA distribution: Artbook/DAP
155 Sixth Avenue, 2nd Floor,
New York, NY 10013
www.artbook.com
UK distribution: TURNAROUND
www.turnaround-uk.com

Foreword

Re-reading *Cycle of Violence* twenty years after it was first published is for me a striking encounter with my younger, angrier self. In 1992 I had just become a father and was coping with the stresses of caring for a newborn. I had left art college a decade before and my career had not yet taken off. I was horribly insecure and, maybe, a touch bitter. I was certainly less reflective, I expressed myself with little impulse control. Quite handy for an artist that.

The responsibilities of being a parent prompted me to start facing up to some of the less helpful emotional traits I had acquired. The physicality of the parenting relationship reignites very primal somatic memories. Looking after a child cannot help but take us back to our own childhood. Again and again I feel I am, like many artists, lashed to a wheel that forces me to constantly recycle my biography, each version coloured a little differently, perhaps by increasing age, hopefully wisdom and maybe forgiveness. What fascinates me about this graphic novella is how much of my self and the world of the unconscious I understood even then. I had gleaned snippets from my wife, Philippa, as she was training to be a psychotherapist at the time. I remember mocking the jargon and earnestness of her fellow trainees yet on some level I appreciated the truths they talked of.

It was not until 1998 that deep unhappiness forced me to put aside my cynicism and enter into therapy. I gave this little book to my therapist in the first few weeks of our work together. Maybe I was desperate to please him, maybe I thought it would be a helpful window into my mind. I vividly remember him accepting it as if I had given him a bag of dog shit to dispose of. Perhaps he was so determined not to seem

pleased, not to blur the therapeutic contract, that he overdid the tight-lipped neutrality of his expression and seemed to me to be a touch disgusted! Such is the nature of psychotherapy that we often read great significance into the tiniest gesture.

The root of all my work lies in my childhood but this story more than most has a clear connection to the emotional fuck-ups of my adolescence. When I was 12 or 13 I drew a series of short comic-strip adventures featuring an idealised male hero called Riff-Raf. As the hormones of puberty flooded through me these boy's-own tales became increasingly kinky, involving much cross-dressing and bondage. Sadly these live frontline reports from my teenage subconscious were lost in the upheavals of family dysfunction. When I became a father myself I revisited the genre with perhaps a more jaundiced and mischievous eye to create the *Cycle of Violence*.

The fictional connections I drew between events in childhood and adult behaviour are perhaps in retrospect on the crude side. I think I unwittingly narrated a tale that still rings true if only as a cautionary metaphor. This instinctual expression of my psychic state I now recognise in many of my artworks from that period in various media. In 1992 I was still an open wound, but I was unfailingly authentic. One part of my personality that has stood me in good stead throughout my career is a well-tuned bullshit detector.

The look of *Cycle of Violence* reflects my dedication to finding an emotional truth. Though familiar with the slick layouts and cinematic pace of most comic books I opted (I like to believe!) consciously for a clunky, even naïve style. Since college my constant touchstones for artistic integrity are the greats of outsider art like Adolf Wölfli or Henry Darger. Disturbed individuals who spontaneously created beautiful imagined worlds for no other reason than their burning need to express. Part of me identifies with their process. If I had been unlucky and had not gone to art school, come to London, met my wife, how then might I have channelled my rage and sensitivity?

When I was 15 or 16 my art teacher had taken me aside after

watching yet another of my priapic sexual fantasies leak out on to the paper. Probably involving a pneumatic bimbo in high heels and a ridiculously phallic car. He said that sex had been an inspiration to artists throughout the ages but it could get in the way! At 32 it was still clouding my vision and it is the sadomasochistic content of *Cycle of Violence* that leaves me feeling uncomfortable today. Re-reading the work I feel now like a boring social worker visiting a problem family. I feel like Martin Dysart, the dissatisfied psychiatrist in Peter Shaffer's *Equus*, who was envious of the all-consuming commitment and passionate "worship" apparent in the troubled behaviour of his patients. I look nostalgically into the cauldron of my own libido, how driven by dark forces I was, how distanced and "aware" of them I am now. Now I am "happy".

Perhaps for me in 2012 the most striking aspect of this tale is the unwitting prescience of its setting. Green causes, like reducing carbon emissions and recycling, are now the religion of the middle classes and issues around sexuality often dominate the political agenda. To top it all, riding a bicycle has never been so popular and Britain is a major force in competitive cycling — a British racing cyclist named Bradley (Wiggins) came fourth in the 2009 Tour de France, he crashed out dramatically in the 2011 Tour and as I write is poised in his best ever form to do well in 2012. Weird!

Grayson Perry

Cycle
of
Violence

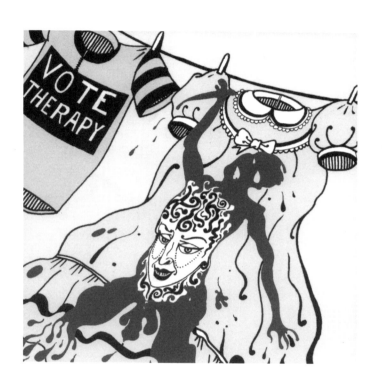

IN THE CLOSING YEARS OF THE REIGN OF **CHARLES III** OF **ENGLAND** THE WORLD IS A MOSTLY PEACEFUL PLACE. MOST PEOPLE HAVE ENOUGH TO EAT AND ALMOST EVERYONE IS EQUAL MOST OF THE TIME. IT IS ALSO A **GREENER** WORLD, THERE ARE NO MORE NUCLEAR WEAPONS OR POWER, THERE ARE FEWER CARS AND MORE TREES. DESPITE THIS GROWING UTOPIA THERE IS STILL ONE TERRIBLE EVIL ENEMY— THAT IS GROWING INSIDE **BRADLEY GAINES.**

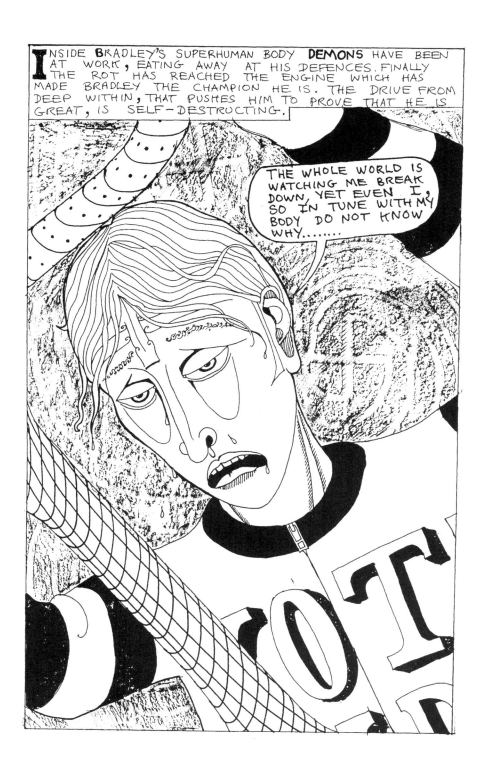

INSIDE BRADLEY'S SUPERHUMAN BODY **DEMONS** HAVE BEEN AT WORK, EATING AWAY AT HIS DEFENCES. FINALLY THE ROT HAS REACHED THE ENGINE WHICH HAS MADE BRADLEY THE CHAMPION HE IS. THE DRIVE FROM DEEP WITHIN, THAT PUSHES HIM TO PROVE THAT HE IS GREAT, IS SELF-DESTRUCTING.

THE WHOLE WORLD IS WATCHING ME BREAK DOWN, YET EVEN I, SO IN TUNE WITH MY BODY DO NOT KNOW WHY.......

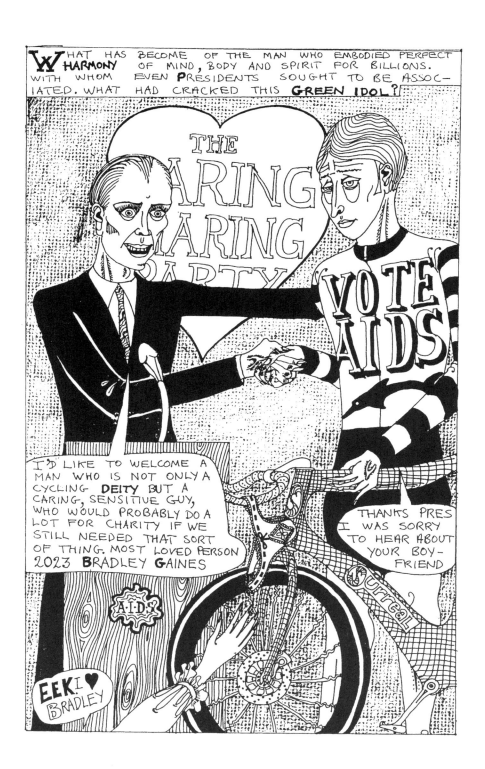

THE WORLDWIDE AUDIENCE WATCHES WITH BAITED BREATH AS BRADLEY'S ZILLION DOLLAR LEGS IMPLODE AND HIS PACE SLOWS TO A CRAWL. HE FEELS THE WARM GLOW OF PUBLIC ADORATION BECOME A SEARING HEAT RAY WHICH BURNS DEEP INTO HIS SOUL

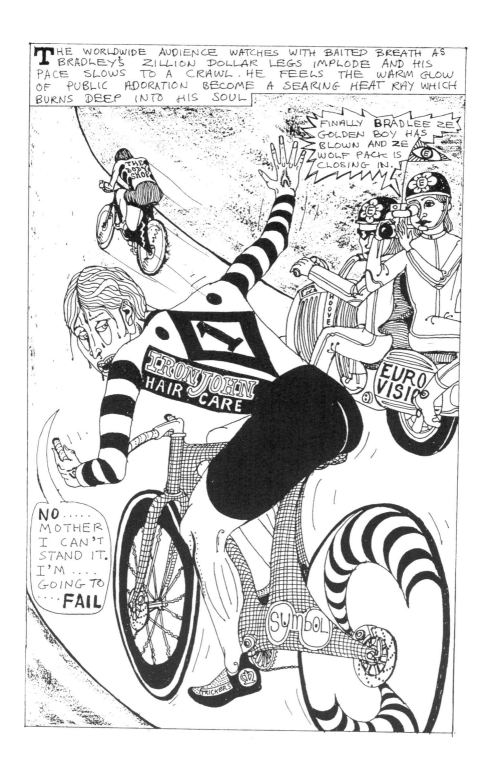

WITH A CRY WHICH ECHOES FROM HIS **DARKEST DEPTHS** BRADLEY COLLAPSES. DEFEATED AND BLEEDING HE HAS A VISION SO TERRIFYING HE CLUTCHES AT THE AIR AS IF TO STRANGLE HIS **PERSONAL GHOST** WHICH HAS RETURNED TO HAUNT HIM AT THE MOMENT OF HIS DOWN-FALL.

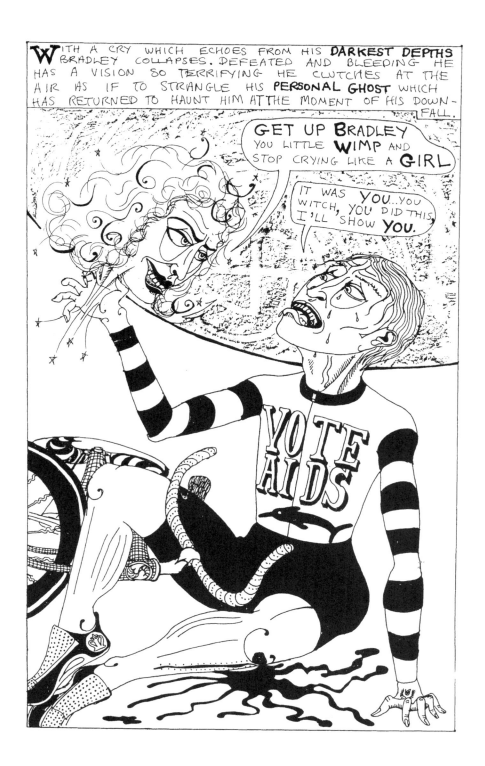

GET UP BRADLEY YOU LITTLE **WIMP** AND STOP CRYING LIKE A **GIRL**

IT WAS **YOU**...YOU WITCH, YOU DID THIS, I'LL SHOW **YOU**.

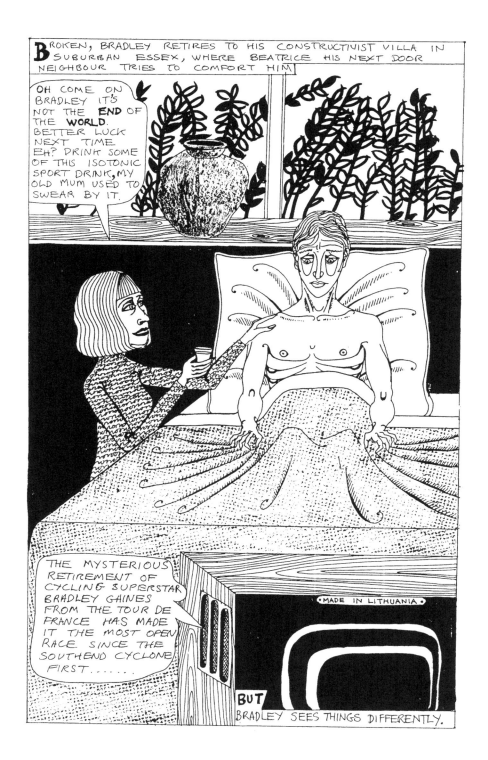

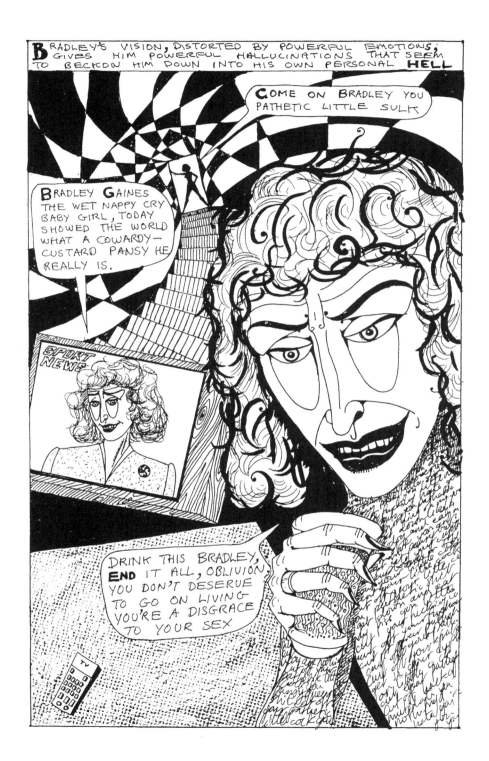

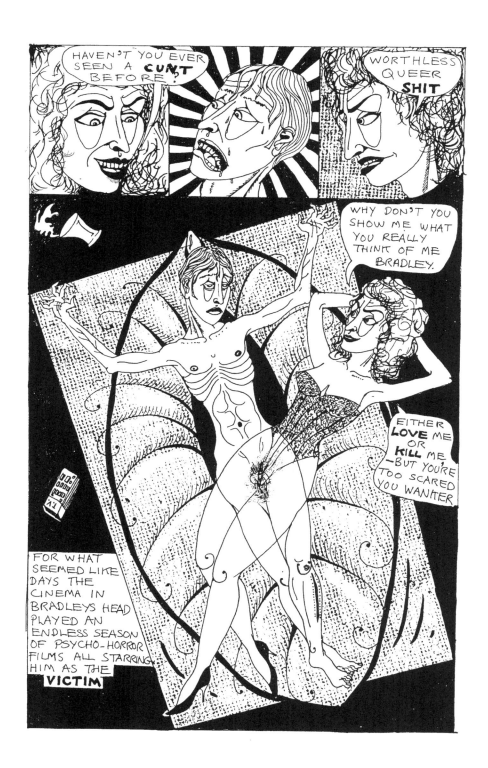

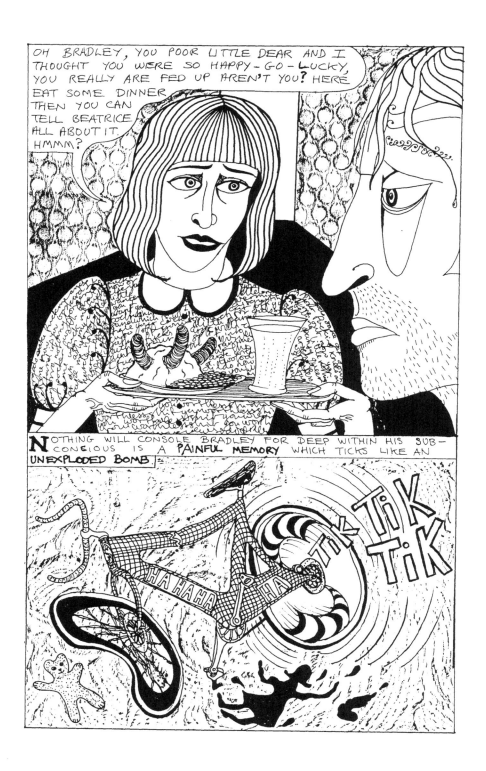

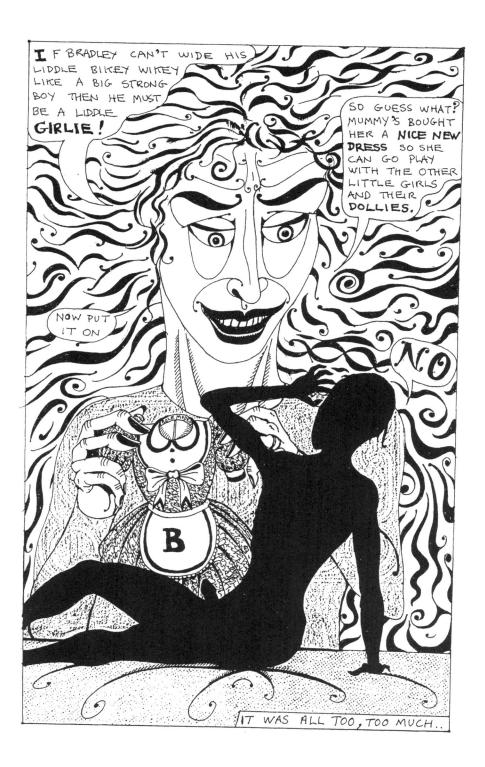

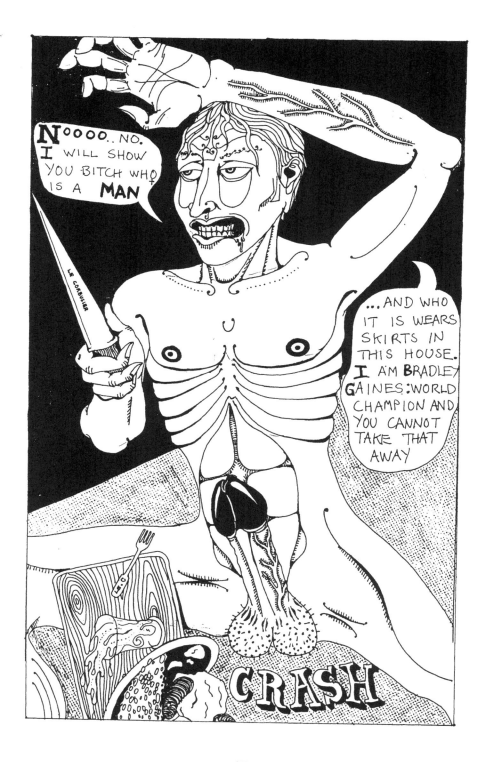

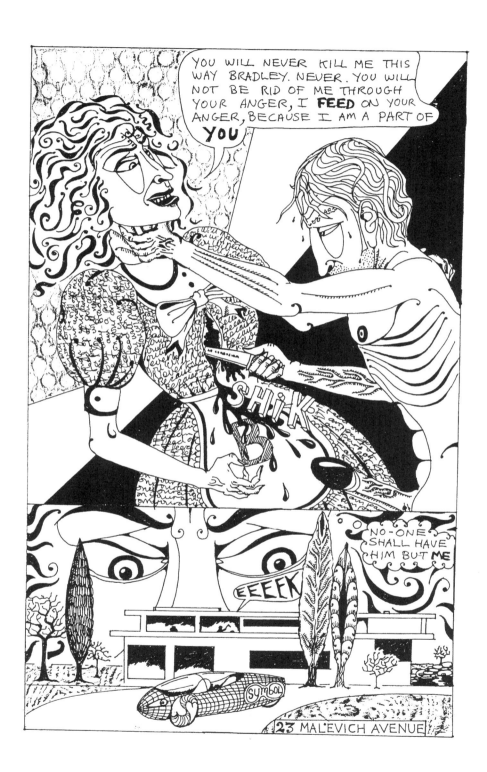

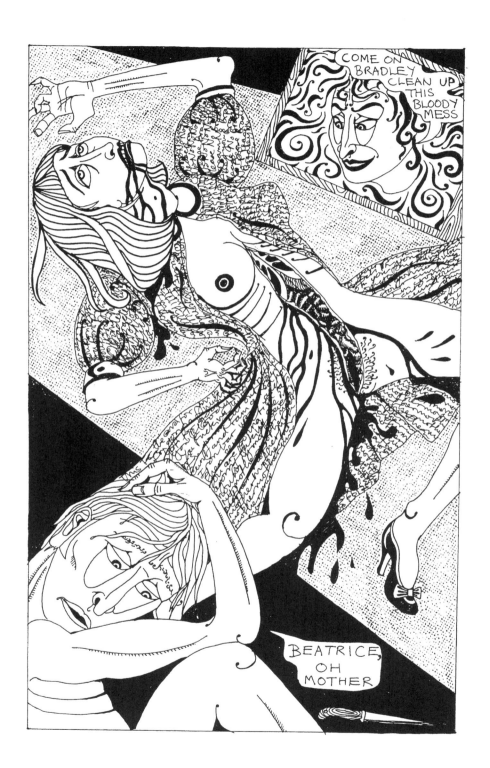

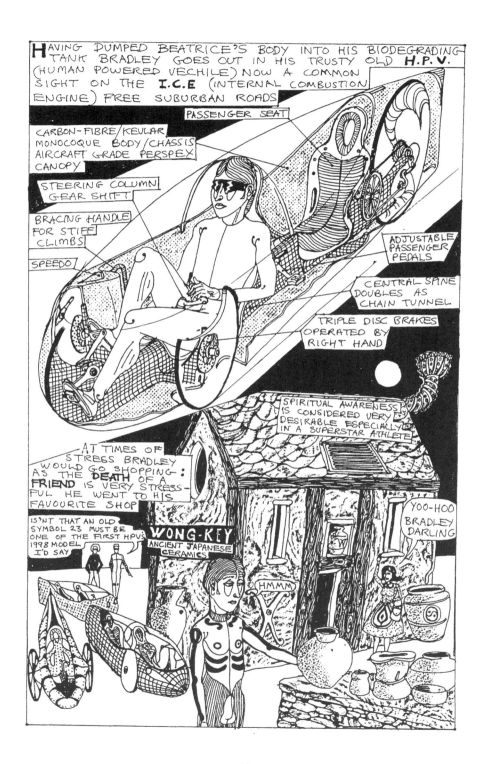

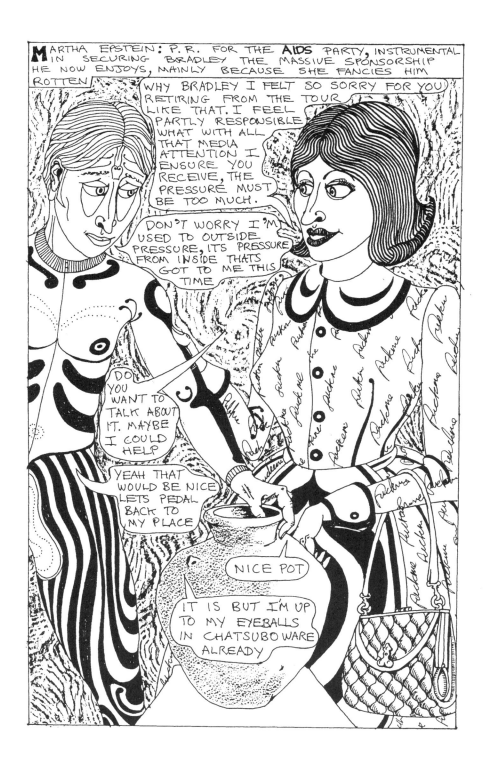

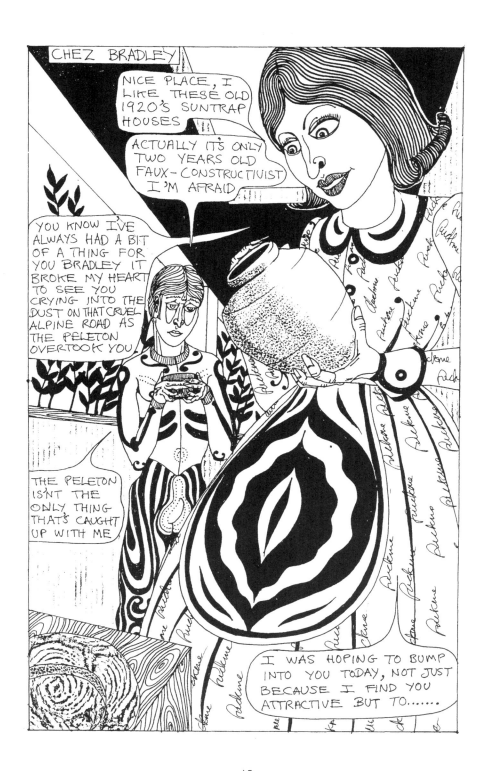

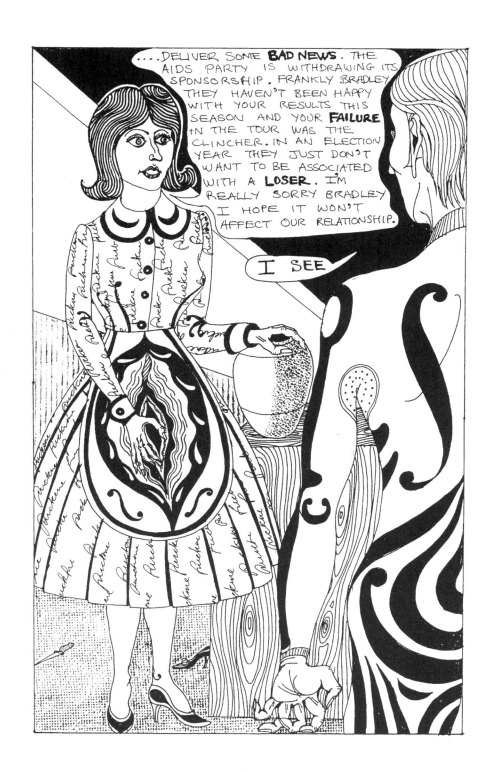

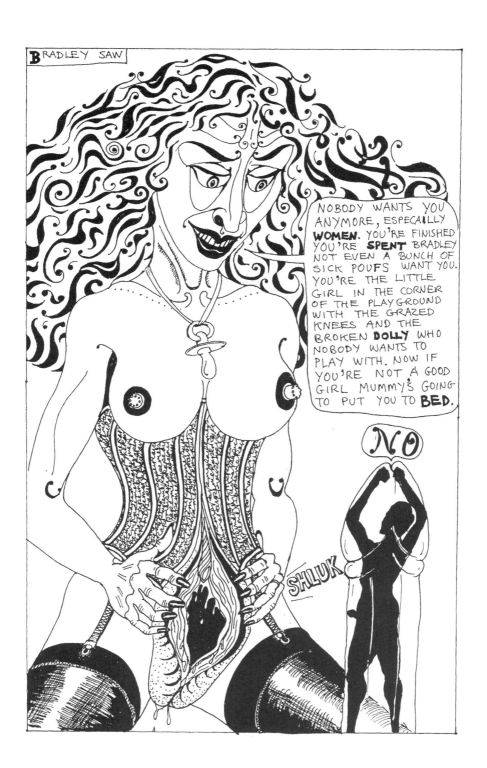

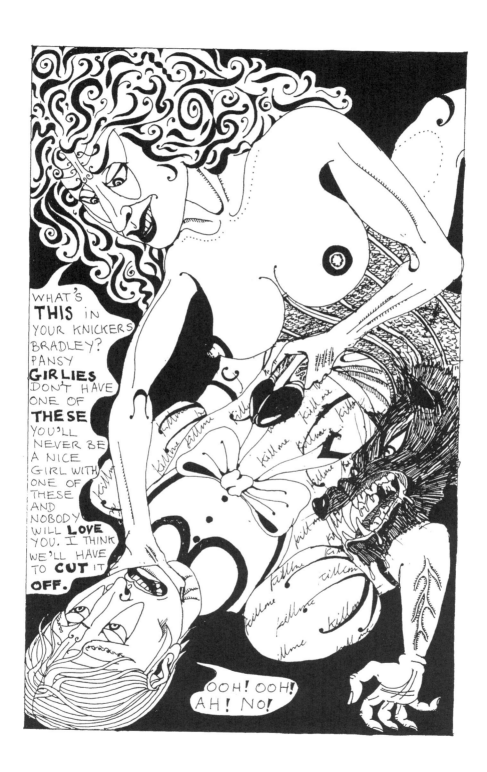

WHAT'S **THIS** IN YOUR KNICKERS BRADLEY? PANSY **GIRLIES** DON'T HAVE ONE OF **THESE** YOU'LL NEVER BE A NICE GIRL WITH ONE OF THESE AND NOBODY WILL **LOVE** YOU. I THINK WE'LL HAVE TO **CUT** IT **OFF.**

OOH! OOH! AH! NO!

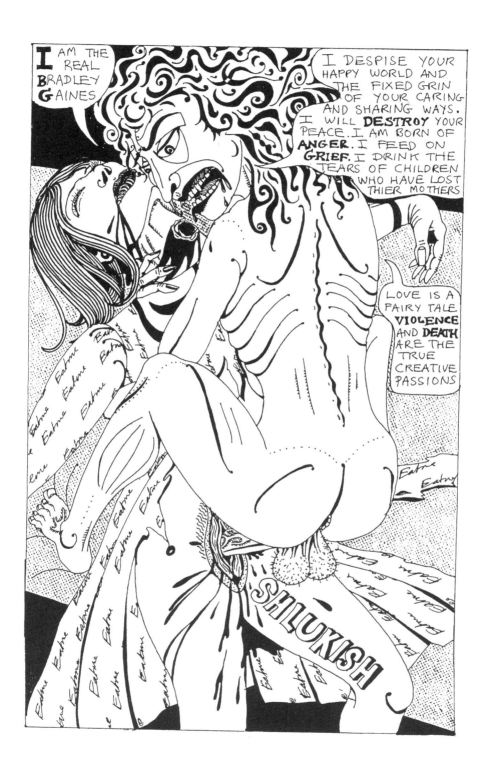

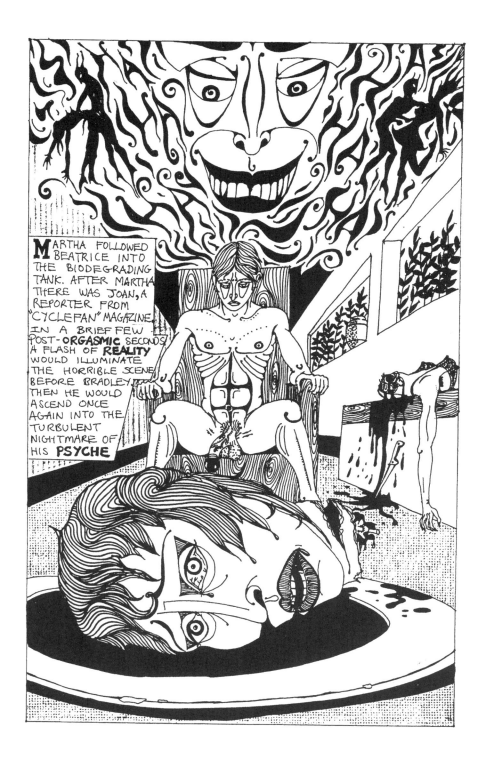

MARTHA FOLLOWED BEATRICE INTO THE BIODEGRADING TANK. AFTER MARTHA THERE WAS JOAN, A REPORTER FROM "CYCLEFAN" MAGAZINE. IN A BRIEF FEW POST-**ORGASMIC** SECONDS A FLASH OF **REALITY** WOULD ILLUMINATE THE HORRIBLE SCENE BEFORE BRADLEY. THEN HE WOULD ASCEND ONCE AGAIN INTO THE TURBULENT NIGHTMARE OF HIS **PSYCHE**

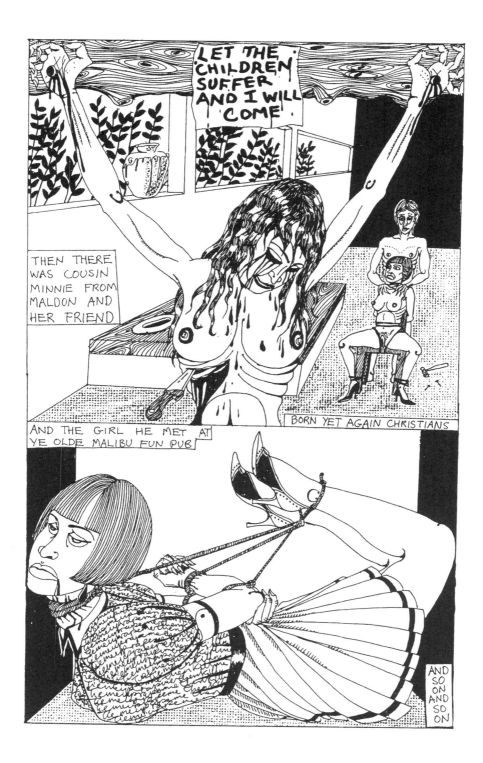

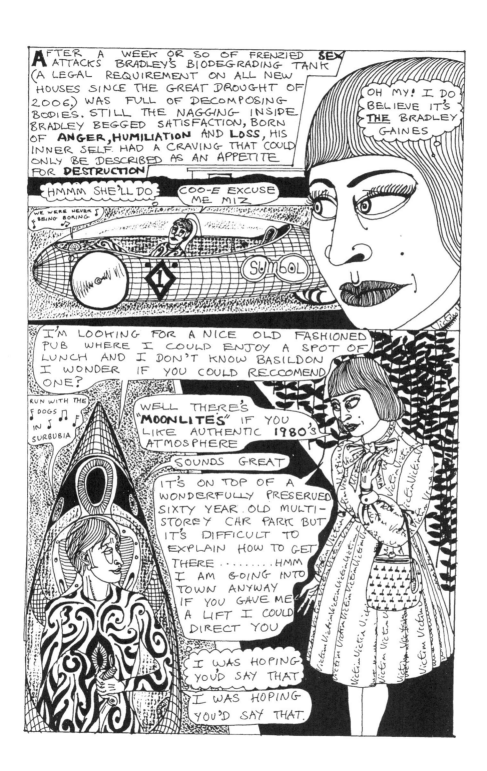

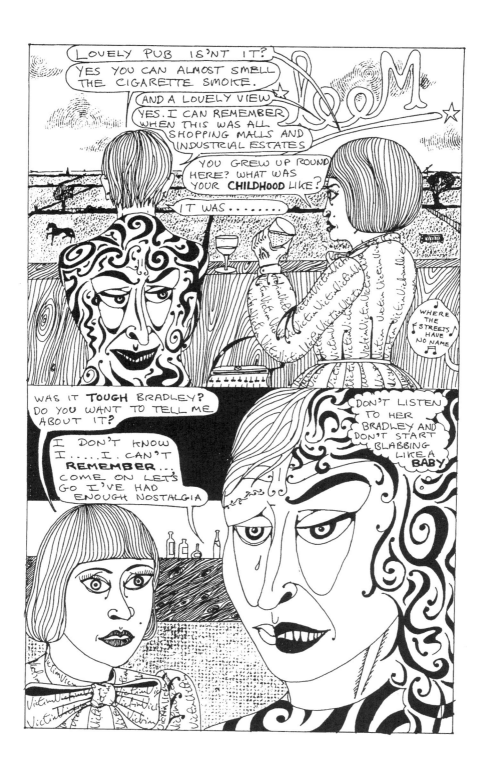

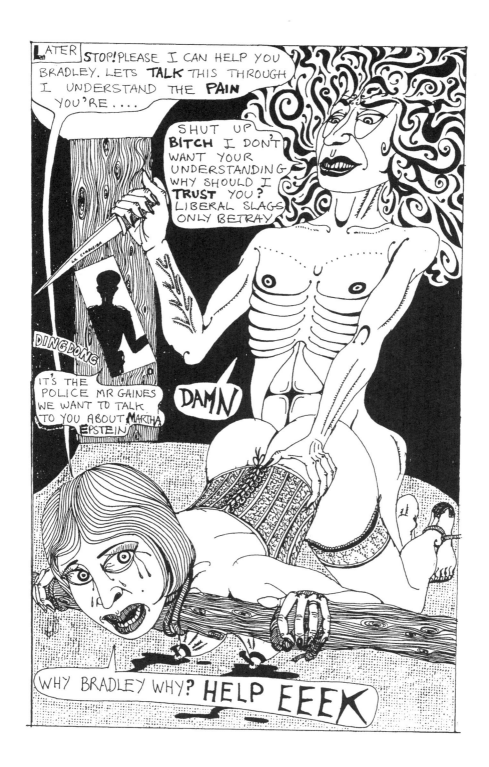

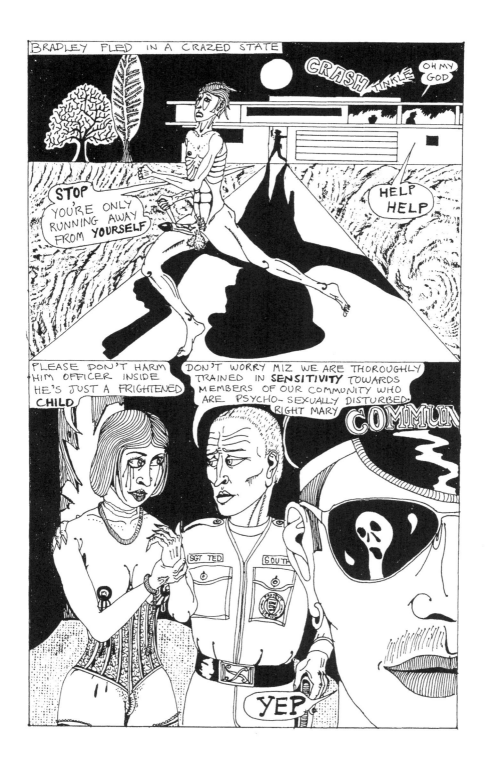

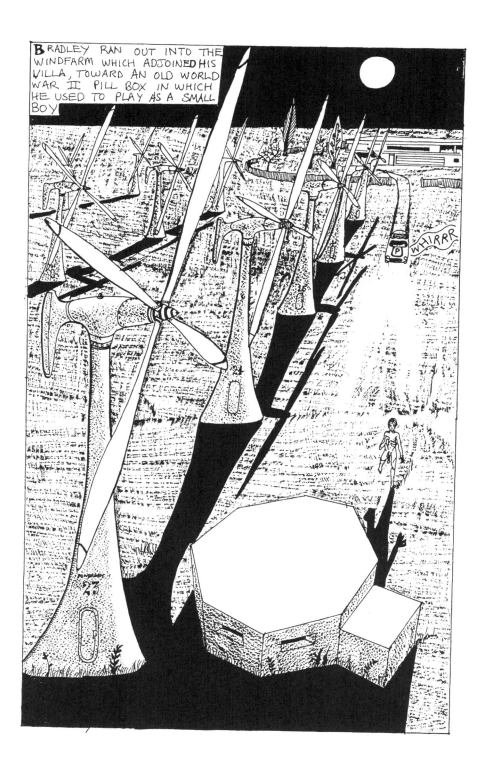

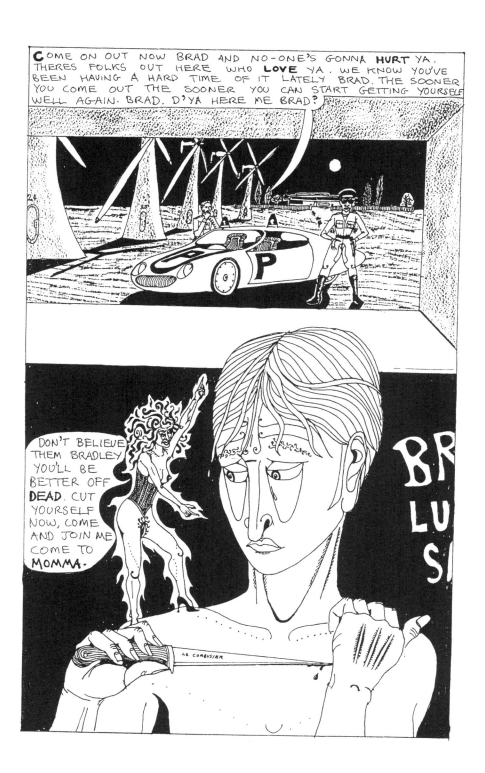

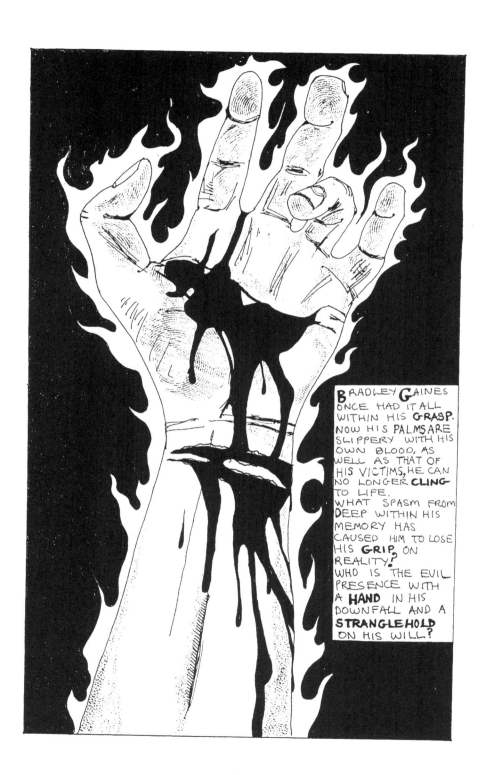

BRADLEY GAINES ONCE HAD IT ALL WITHIN HIS GRASP. NOW HIS PALMS ARE SLIPPERY WITH HIS OWN BLOOD, AS WELL AS THAT OF HIS VICTIMS, HE CAN NO LONGER CLING TO LIFE.
WHAT SPASM FROM DEEP WITHIN HIS MEMORY HAS CAUSED HIM TO LOSE HIS GRIP ON REALITY?
WHO IS THE EVIL PRESENCE WITH A HAND IN HIS DOWNFALL AND A STRANGLEHOLD ON HIS WILL?

TO FIND OUT THE ANSWERS WE MUST GO BACK TO A TIME BRADLEY CANNOT RECALL. THE **MURDEROUS SEED** WAS SOWN LONG BEFORE HIS **FALL** ON THAT MOUNTAIN ROAD.

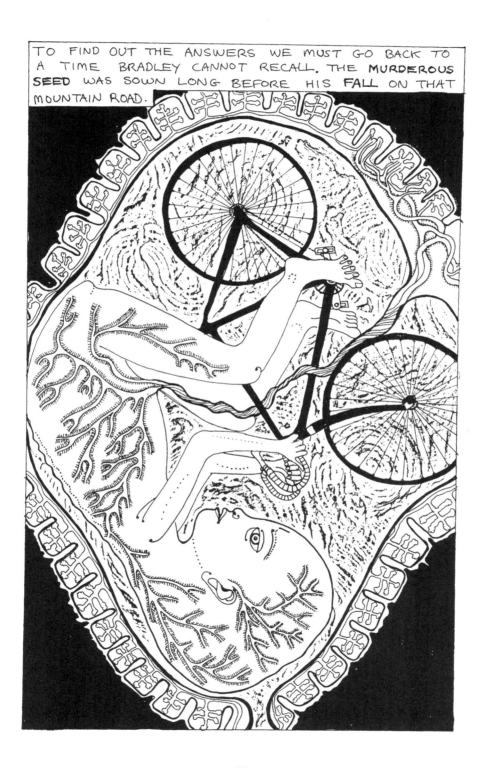

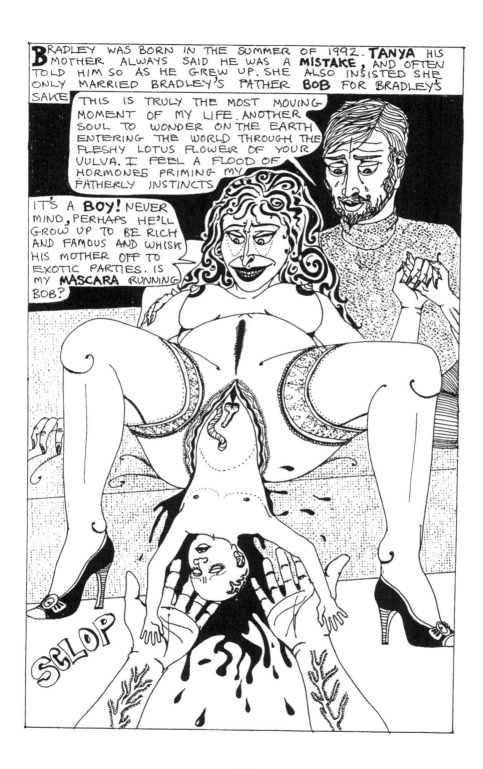

BRADLEY WAS BORN IN THE SUMMER OF 1992. **TANYA** HIS MOTHER ALWAYS SAID HE WAS A **MISTAKE**, AND OFTEN TOLD HIM SO AS HE GREW UP. SHE ALSO INSISTED SHE ONLY MARRIED BRADLEY'S FATHER **BOB** FOR BRADLEY'S SAKE.

THIS IS TRULY THE MOST MOVING MOMENT OF MY LIFE. ANOTHER SOUL TO WONDER ON THE EARTH ENTERING THE WORLD THROUGH THE FLESHY LOTUS FLOWER OF YOUR VULVA. I FEEL A FLOOD OF HORMONES PRIMING MY FATHERLY INSTINCTS

IT'S A **BOY!** NEVER MIND, PERHAPS HE'LL GROW UP TO BE RICH AND FAMOUS AND WHISK HIS MOTHER OFF TO EXOTIC PARTIES. IS MY **MASCARA** RUNNING BOB?

SCLOP

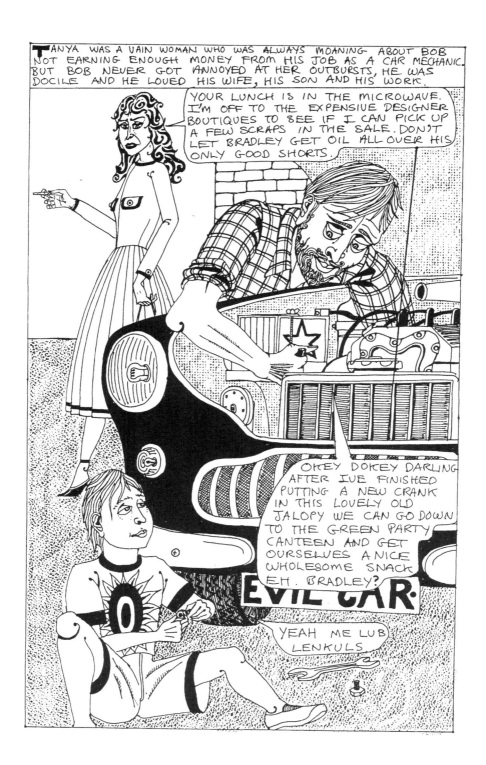

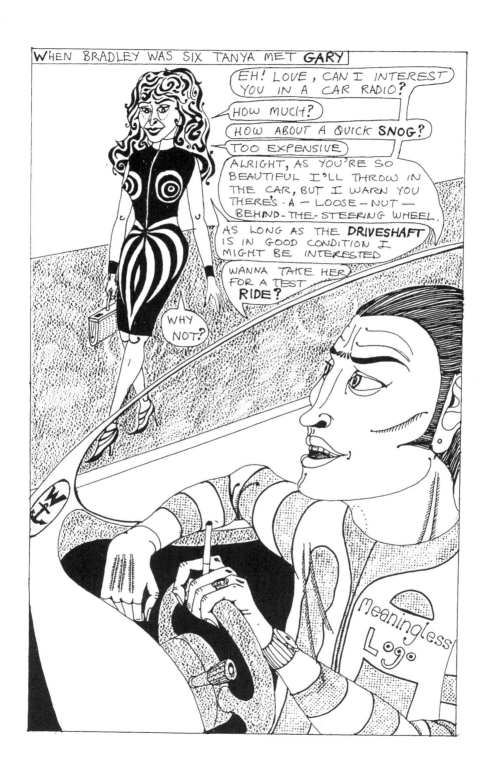

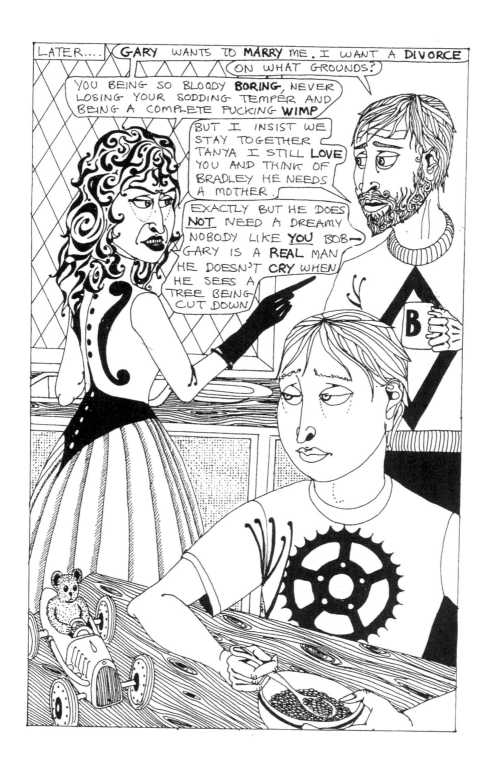

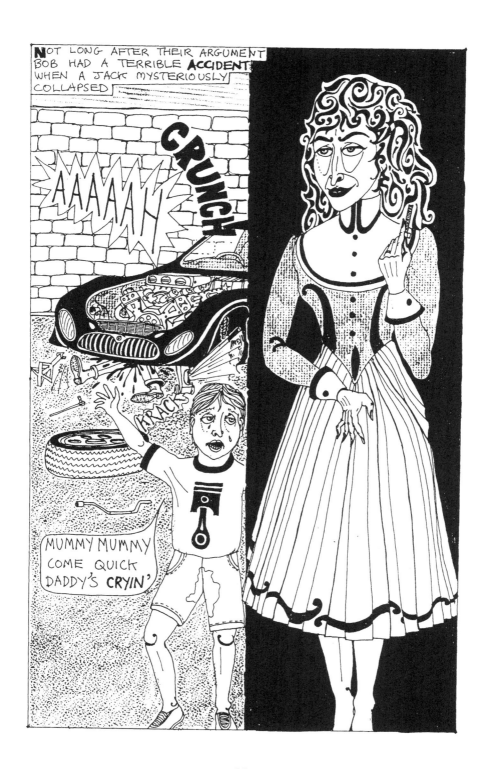

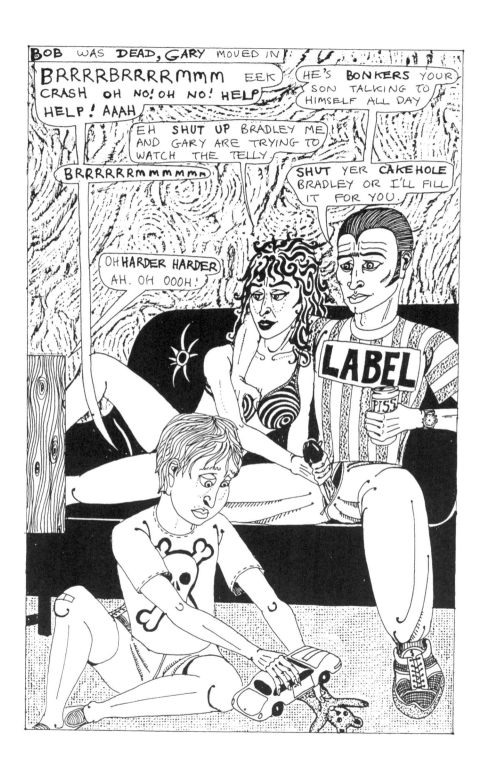

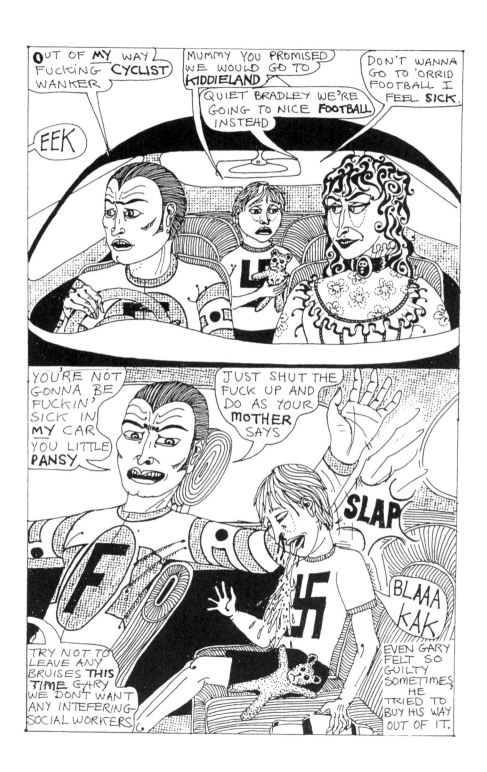

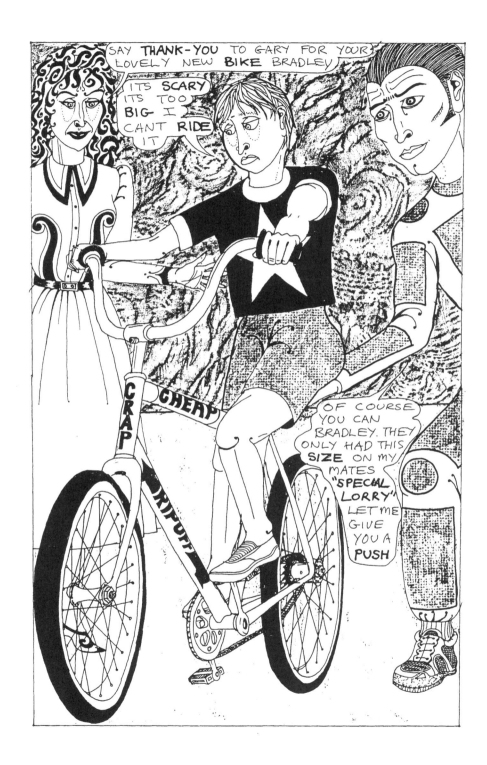

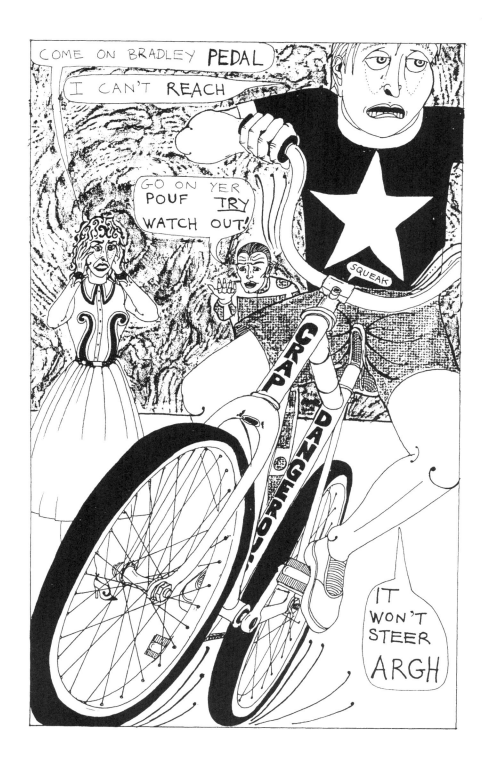

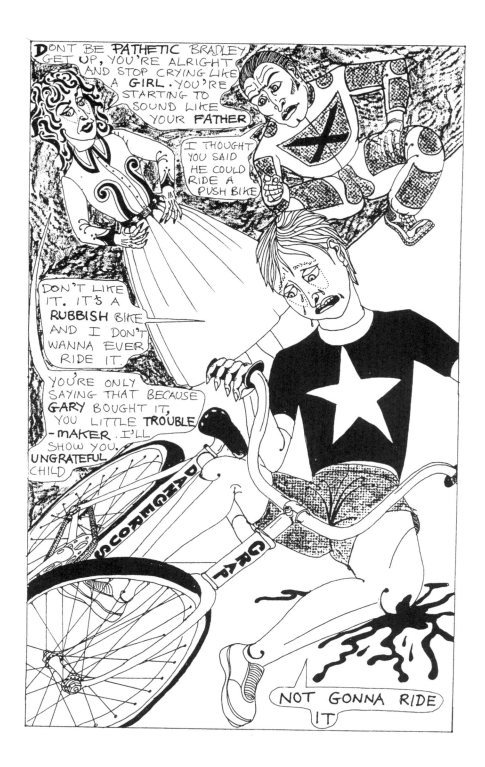

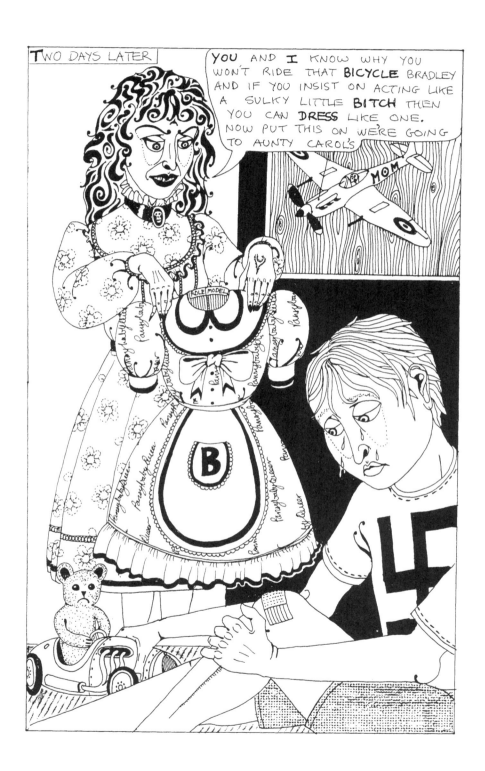

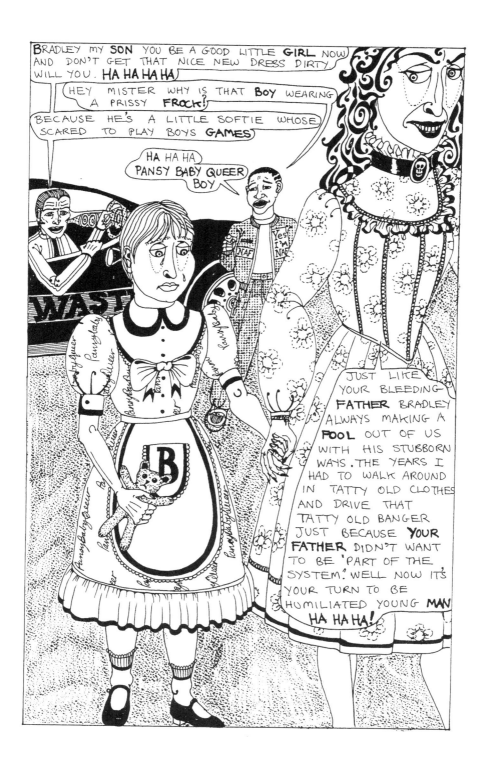

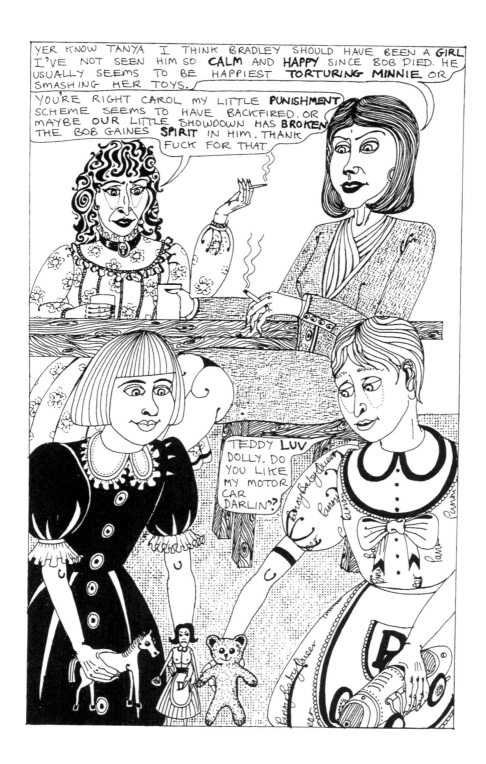

TANYA WAS RIGHT, SOMETHING HAD **SNAPPED** INSIDE BRADLEY. HE GREW UP LARGELY **IGNORED** AS HIS MOTHER AND GARY FOCUSED THEIR ATTENTION ON THEIR DAUGHTER. BRADLEY RETREATED INTO HIS **FANTASY** WORLD. SHE NEVER MADE HIM WEAR A DRESS AGAIN BUT THE **BIKE** RUSTED IN THE SHED

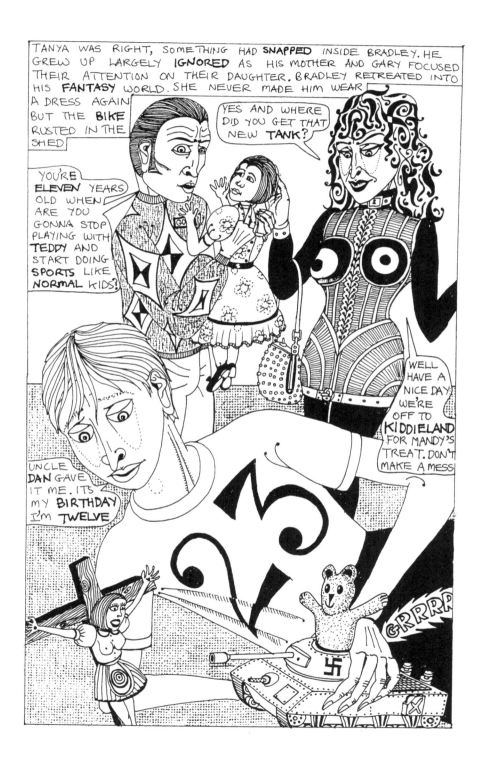

YES AND WHERE DID YOU GET THAT NEW **TANK**?

YOU'RE **ELEVEN** YEARS OLD WHEN ARE YOU GONNA STOP PLAYING WITH **TEDDY** AND START DOING **SPORTS** LIKE **NORMAL** KIDS?

WELL HAVE A NICE DAY. WE'RE OFF TO **KIDDIELAND** FOR MANDY'S TREAT. DON'T MAKE A MESS

UNCLE **DAN** GAVE IT ME. ITS MY **BIRTHDAY** I'M **TWELVE**

GRRRR

FOR HIS THIRTEENTH BIRTHDAY UNCLE **DAN** (BOB'S **BACHELOR** BROTHER, MUCH DESPISED BY TANYA AND GARY) BOUGHT BRADLEY A **RACING BIKE**

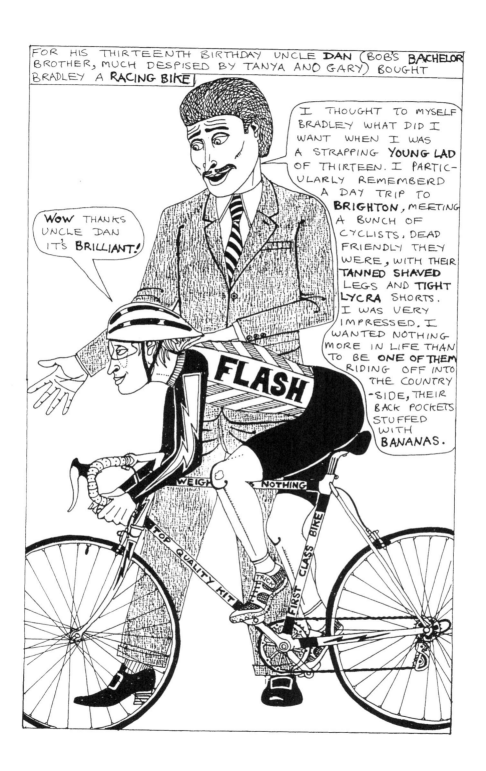

WOW THANKS UNCLE DAN IT'S **BRILLIANT!**

I THOUGHT TO MYSELF BRADLEY WHAT DID I WANT WHEN I WAS A STRAPPING **YOUNG LAD** OF THIRTEEN. I PARTICULARLY REMEMBERD A DAY TRIP TO **BRIGHTON**, MEETING A BUNCH OF CYCLISTS, DEAD FRIENDLY THEY WERE, WITH THEIR **TANNED SHAVED** LEGS AND **TIGHT LYCRA** SHORTS. I WAS VERY IMPRESSED. I WANTED NOTHING MORE IN LIFE THAN TO BE **ONE OF THEM** RIDING OFF INTO THE COUNTRY-SIDE, THEIR BACK POCKETS STUFFED WITH BANANAS.

FLASH

UNFORTUNATELY FOR BRADLEY UNCLE **DAN** DIED THE FOLLOWING YEAR, BEATEN TO DEATH ON **CLAPHAM COMMON**. MAYBE IN LOVING MEMORY OF THE ONE KIND MAN IN HIS LIFE OR MAYBE TO SPITE HIS MOTHER AND GARY, BRADLEY TOOK TO CYCLING WITH A **VENGEANCE. ESSEX** CHAMPION IN HIS FIRST YEAR, **NATIONAL** JUNIOR CHAMP AT FIFTEEN, TURNING **PRO** AT EIGHTEEN, WINNING THREE **MAJOR** RACES IN HIS FIRST YEAR

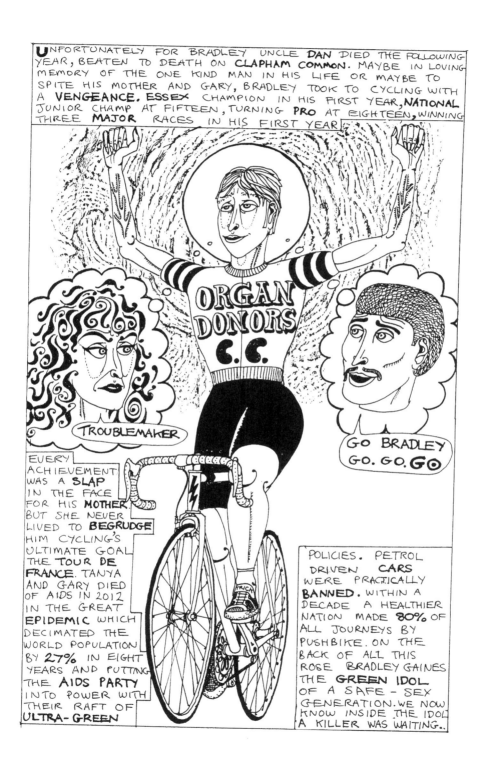

TROUBLEMAKER

GO BRADLEY GO. GO. GO

EVERY ACHIEVEMENT WAS A **SLAP** IN THE FACE FOR HIS **MOTHER** BUT SHE NEVER LIVED TO **BEGRUDGE** HIM CYCLING'S ULTIMATE GOAL THE **TOUR DE FRANCE**. TANYA AND GARY DIED OF AIDS IN 2012 IN THE GREAT **EPIDEMIC** WHICH DECIMATED THE WORLD POPULATION BY **27%** IN EIGHT YEARS AND PUTTING THE **AIDS PARTY** INTO POWER WITH THEIR RAFT OF **ULTRA-GREEN**

POLICIES. PETROL DRIVEN **CARS** WERE PRACTICALLY **BANNED**. WITHIN A DECADE A HEALTHIER NATION MADE **80%** OF ALL JOURNEYS BY PUSHBIKE. ON THE BACK OF ALL THIS ROSE BRADLEY GAINES THE **GREEN IDOL** OF A SAFE - SEX GENERATION. WE NOW KNOW INSIDE THE IDOL A KILLER WAS WAITING..

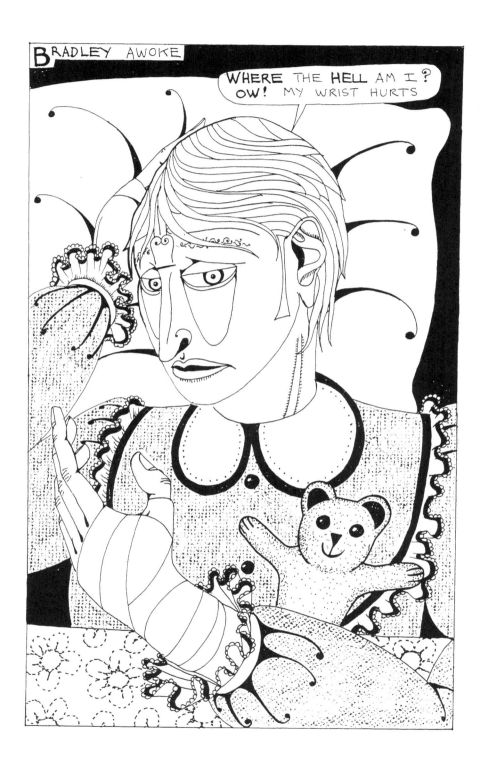

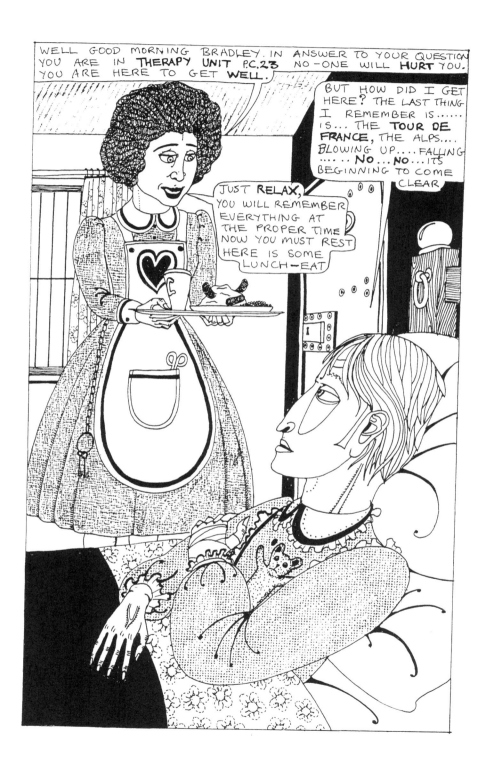

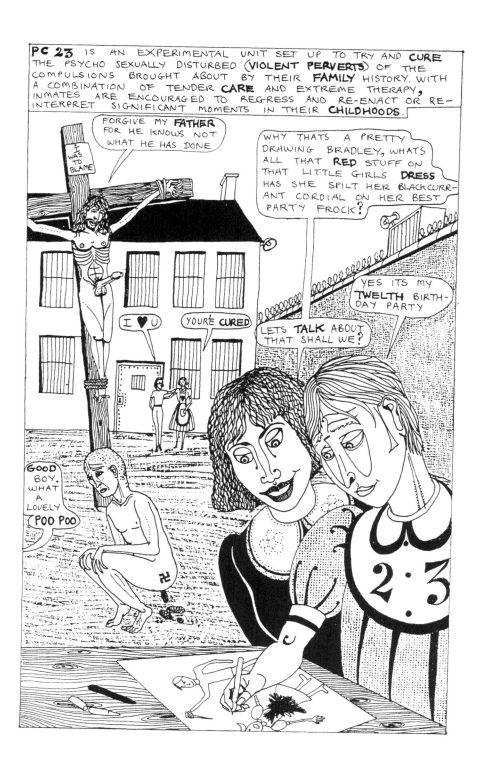

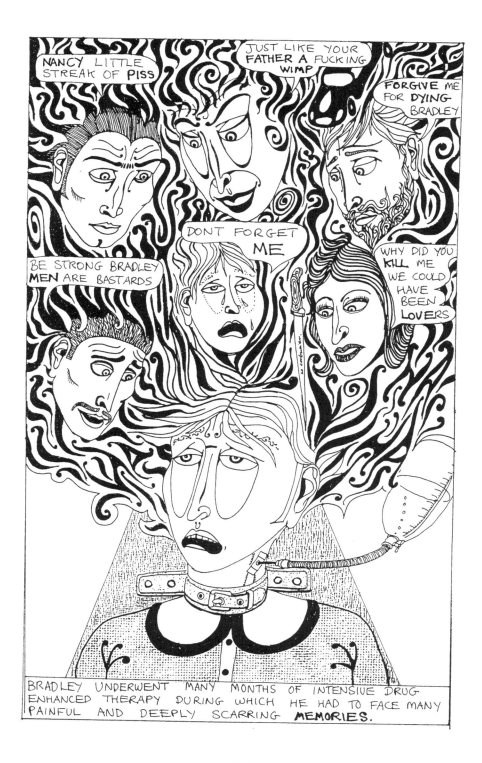

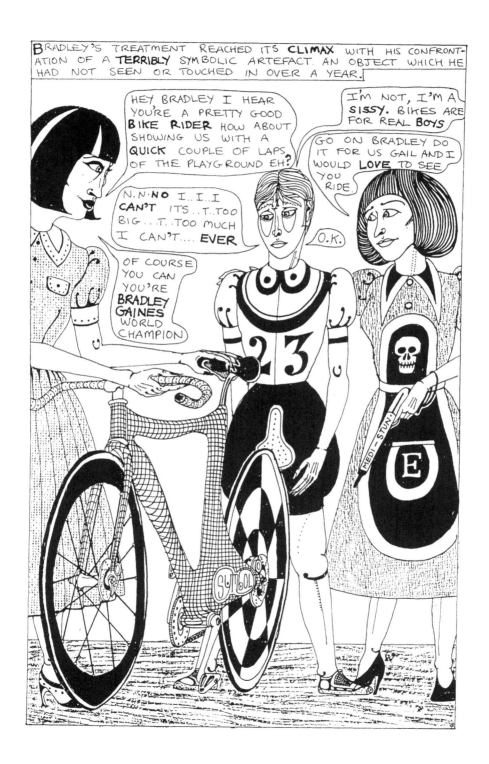

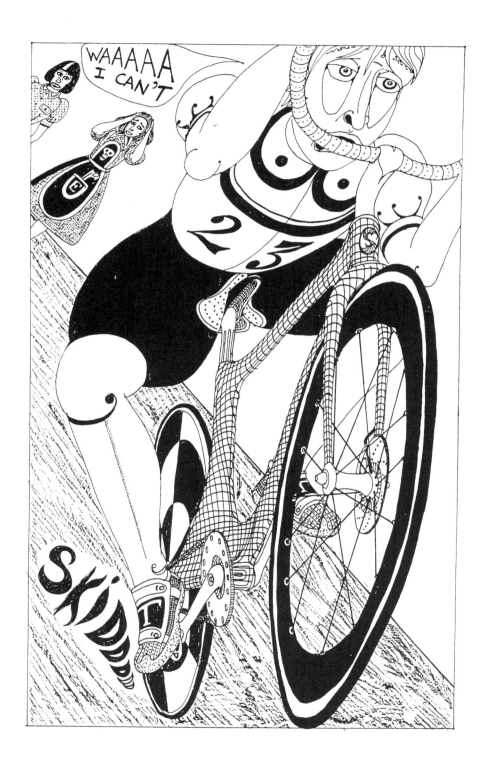

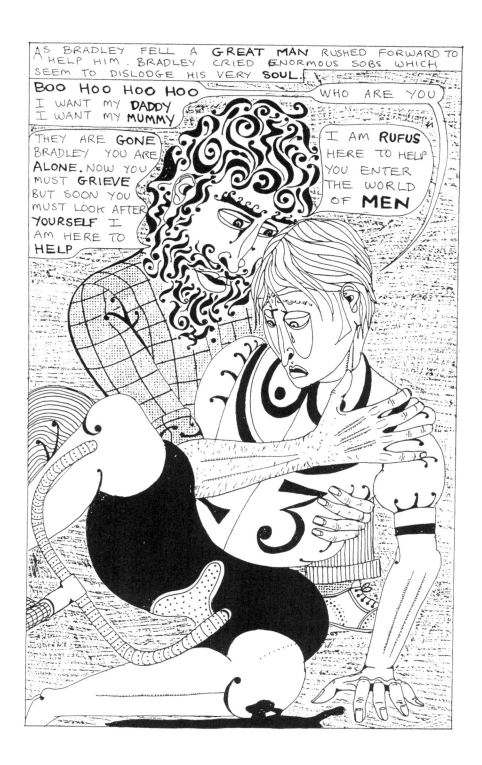

- 119 -

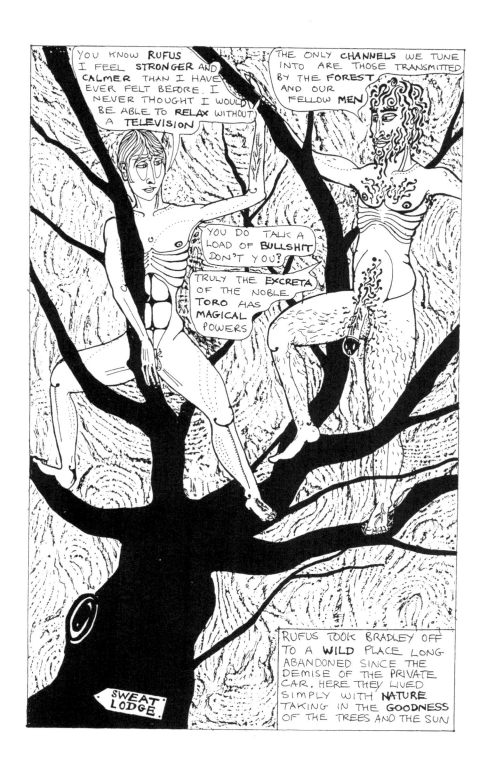

— 121 —

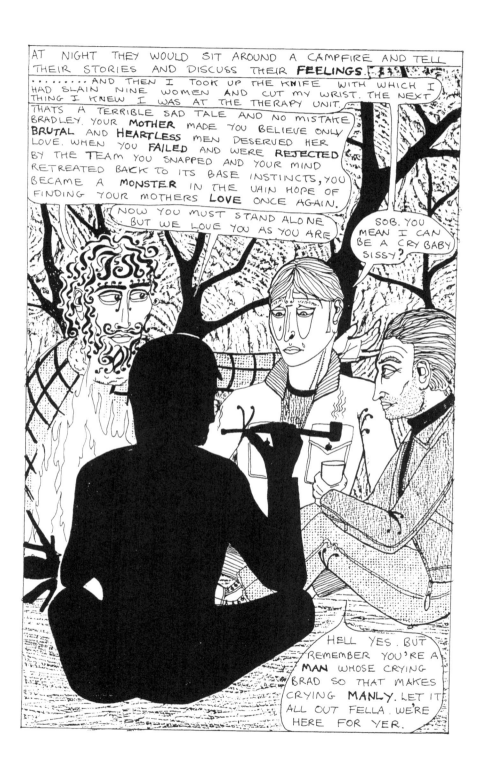

AT NIGHT THEY WOULD SIT AROUND A CAMPFIRE AND TELL THEIR STORIES AND DISCUSS THEIR **FEELINGS**.

........ AND THEN I TOOK UP THE KNIFE WITH WHICH I HAD SLAIN NINE WOMEN AND CUT MY WRIST. THE NEXT THING I KNEW I WAS AT THE THERAPY UNIT.

THATS A TERRIBLE SAD TALE AND NO MISTAKE BRADLEY. YOUR **MOTHER** MADE YOU BELIEVE ONLY **BRUTAL** AND **HEARTLESS** MEN DESERVED HER LOVE. WHEN YOU **FAILED** AND WERE **REJECTED** BY THE TEAM YOU SNAPPED AND YOUR MIND RETREATED BACK TO ITS BASE INSTINCTS, YOU BECAME A **MONSTER** IN THE VAIN HOPE OF FINDING YOUR MOTHERS **LOVE** ONCE AGAIN.

NOW YOU MUST STAND ALONE BUT WE LOVE YOU AS YOU ARE

SOB. YOU MEAN I CAN BE A CRY BABY SISSY?

HELL YES. BUT REMEMBER YOU'RE A **MAN** WHOSE CRYING BRAD SO THAT MAKES CRYING **MANLY**. LET IT ALL OUT FELLA. WE'RE HERE FOR YER.

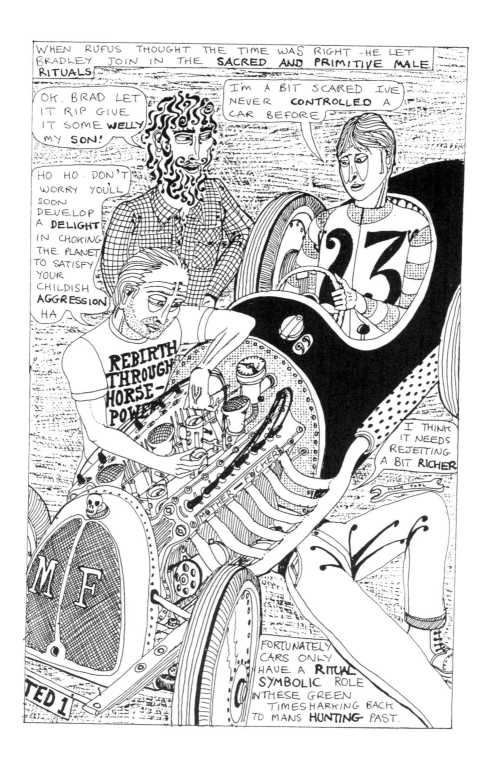

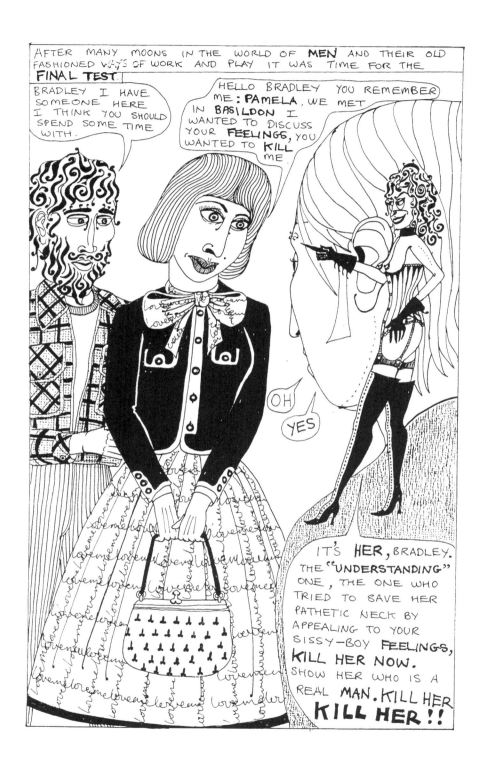

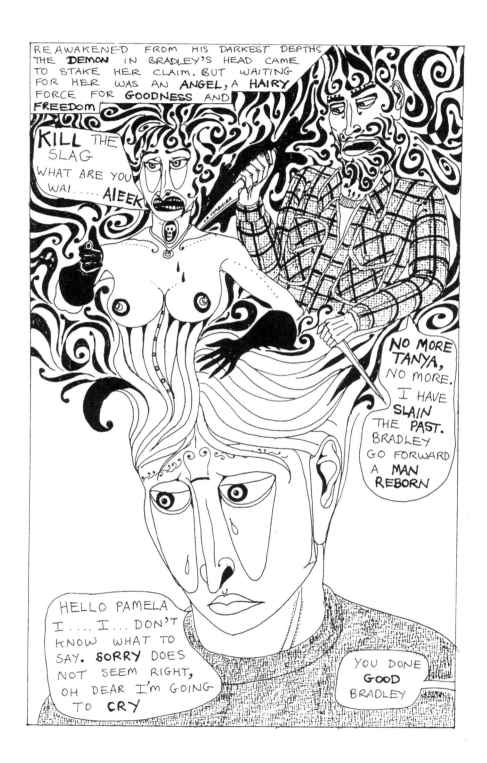

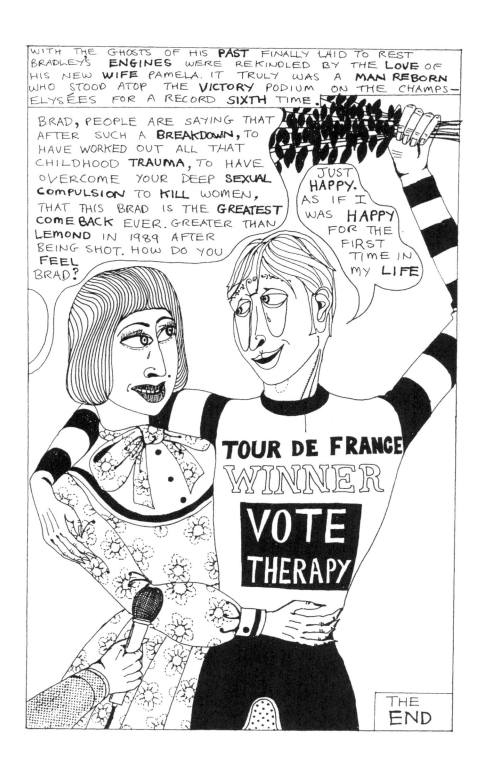

Bibliographic Note

Cycle of Violence was first published by Atlas Press in a small paperbound format as a part of our "Printed Head" series in 1992. There were 300 numbered copies, the first 50 of which were signed. A second edition, also a paperback, of 1000 numbered copies, followed in 2002. (The large-paper signed version of this edition was never produced.) Both these editions were privately published and were only available directly from Atlas Press. The present publication is the first trade edition of this book. The author has decided not to correct the various spelling errors to be found in the drawings.

Atlas Press publications are
distributed in the UK by
Turnaround
(www.turnaround-uk.com)
and in the USA byArtbook/D.A.P.
(www.artbook.com).
A number of our titles are only
available direct. For our complete
catalogue including backlist,
and direct sales, go to
www.atlaspress.co.uk, where you
may also sign on to our emailing list
for news of forthcoming titles.
Most of our publications can be
found at bookartbookshop in
Shoreditch, London (see
www.bookartbookshop.com for
opening hours and further
information).